Swear Word Coloring Book for Adults

IS YOUR STRESS LEVEL HIGH? DO YOU WANT TO SWEAR OUT LOUD TO LEVEL IT DOWN? THIS BOOK WILL KICK YOUR STRESS AWAY!

Multiple studies revealed that coloring mandalas, geometric patterns & other shapes helps reduce stress and anxiety for adults.

This swear word coloring book will allow you to enter in a relaxed state by focusing in what you are doing and blocking out the nonstop thinking or other distractions. Those swear word designs will make you laugh and relieve your stress by expelling your negative thoughts.

This book contains 20 pages of beautiful & intricate designs mixing up with funny swear words that will connect with you.

Each page is single-sided for getting the best coloring experience.

TIME TO COLOR THE STRESS AWAY!

All Rights Reserved. Colorful Swearing Dreams

No part of this book may be reproduced, stored in a retrieval system, or transmitted in any form or by any means, electronic, mechanical, photocopying, recording, or otherwise, without the prior written permission of the author.

Colorful Swar word Coloring Book for Adults

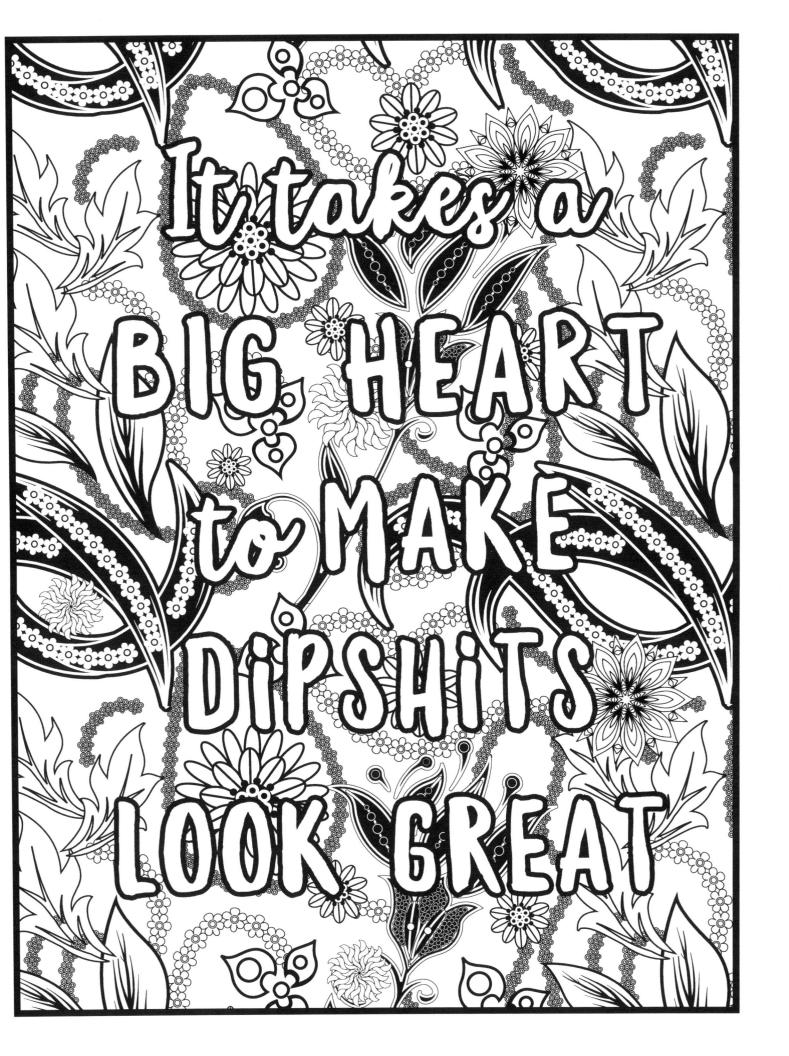

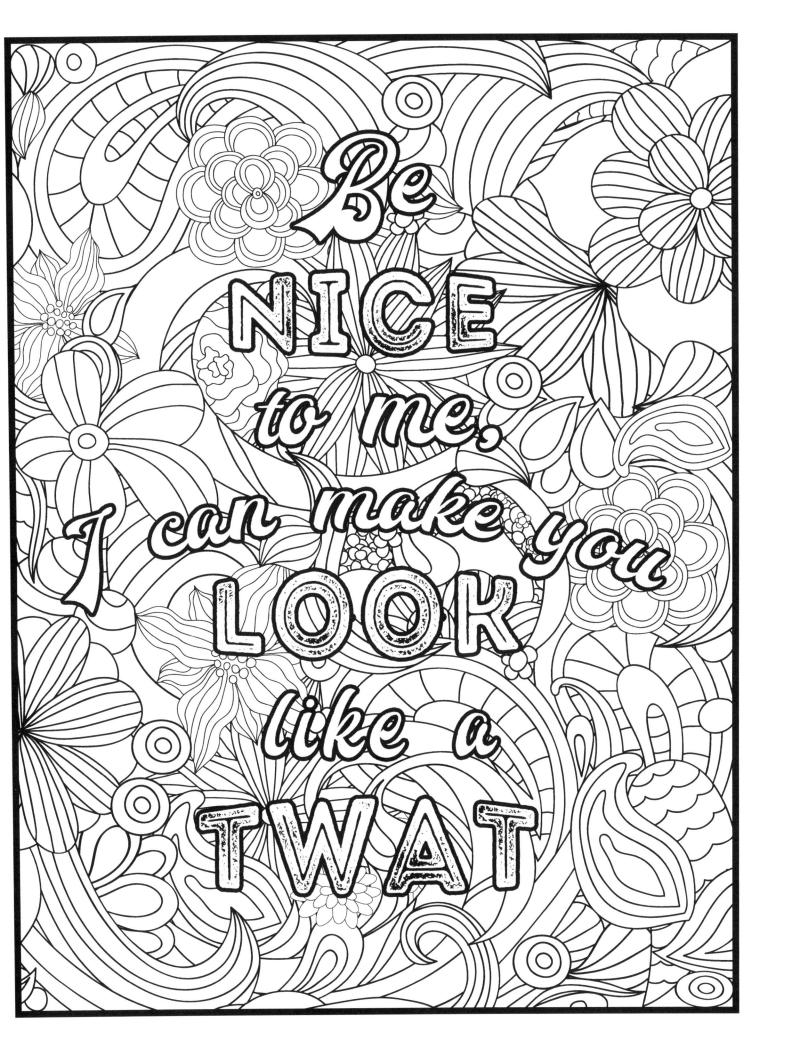

Colorbul Swearing Oreans Swear word Coloring Book for Adults

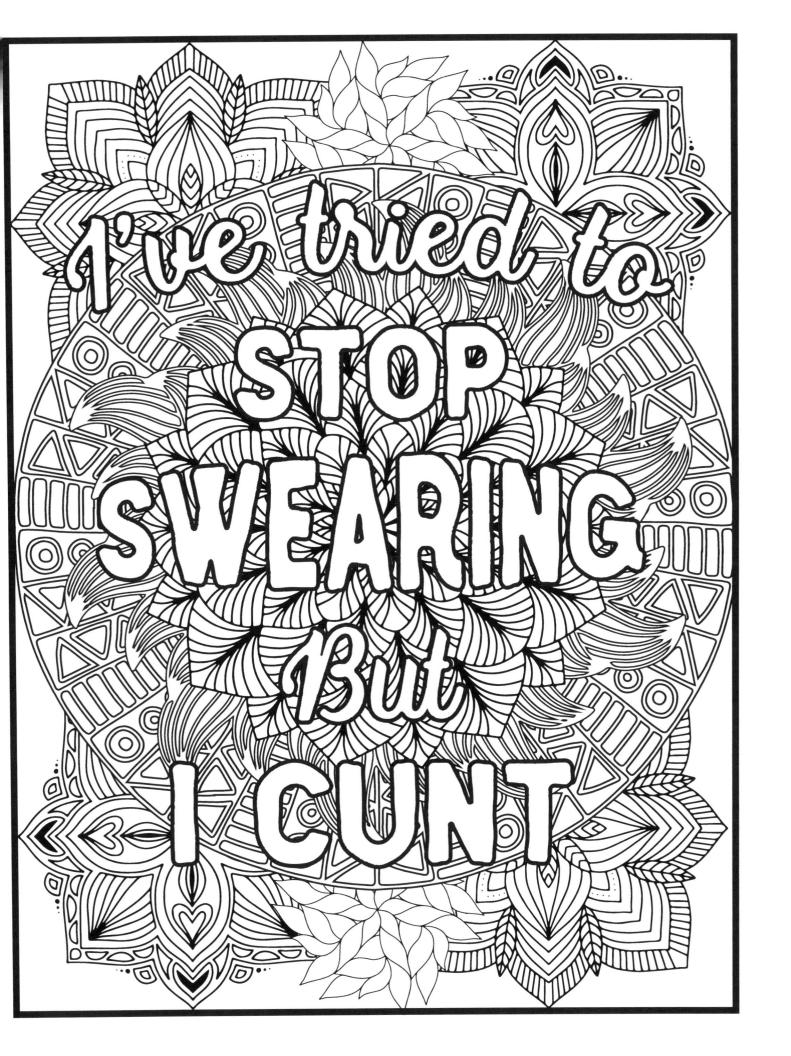

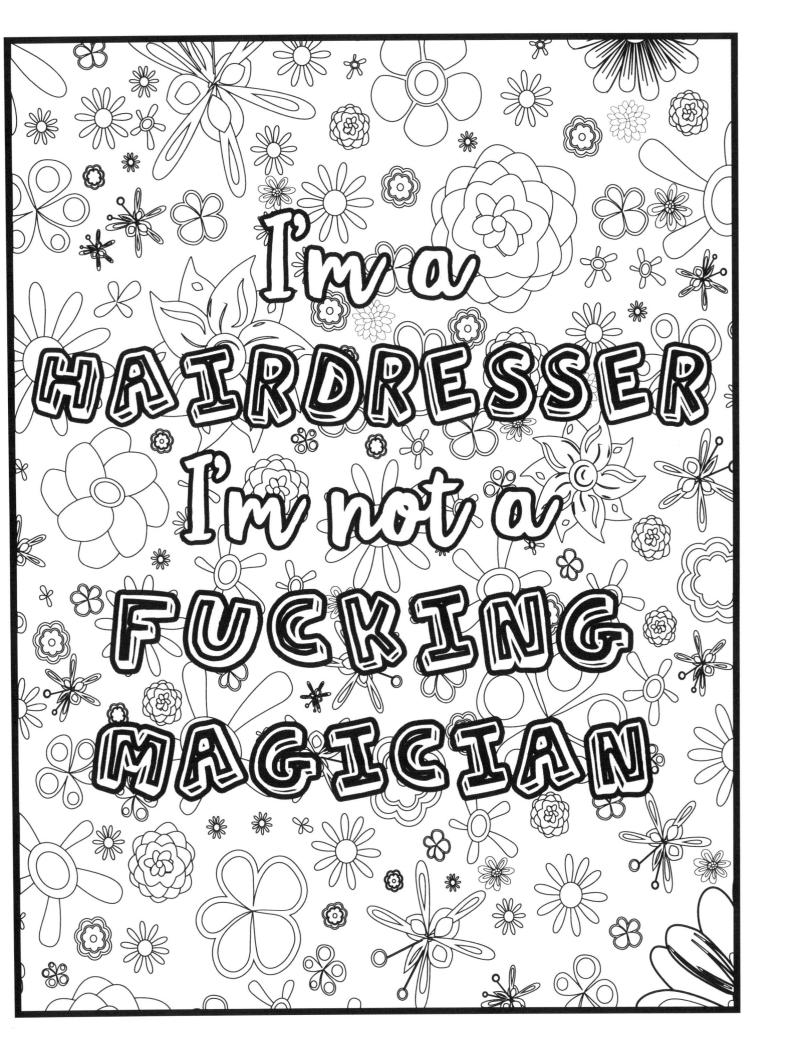

Colorful Swearing Oreans Swear word Coloring Book for Adults

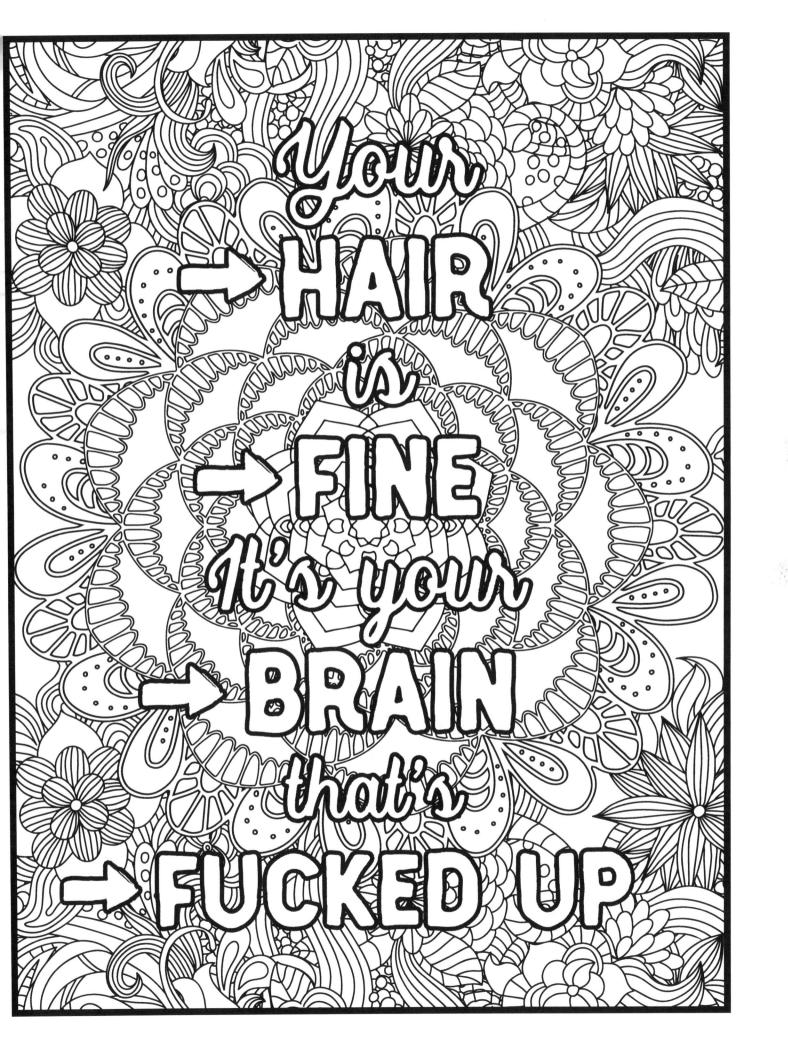

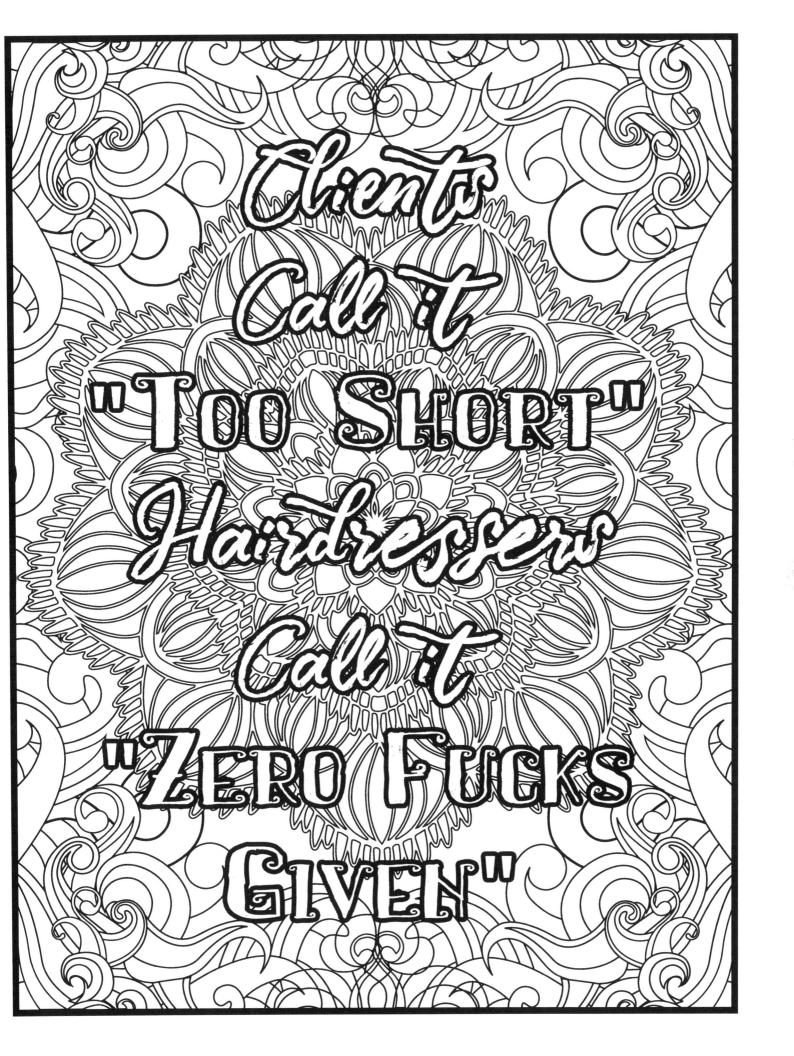

Colorful Swear word Coloring Book for Adults

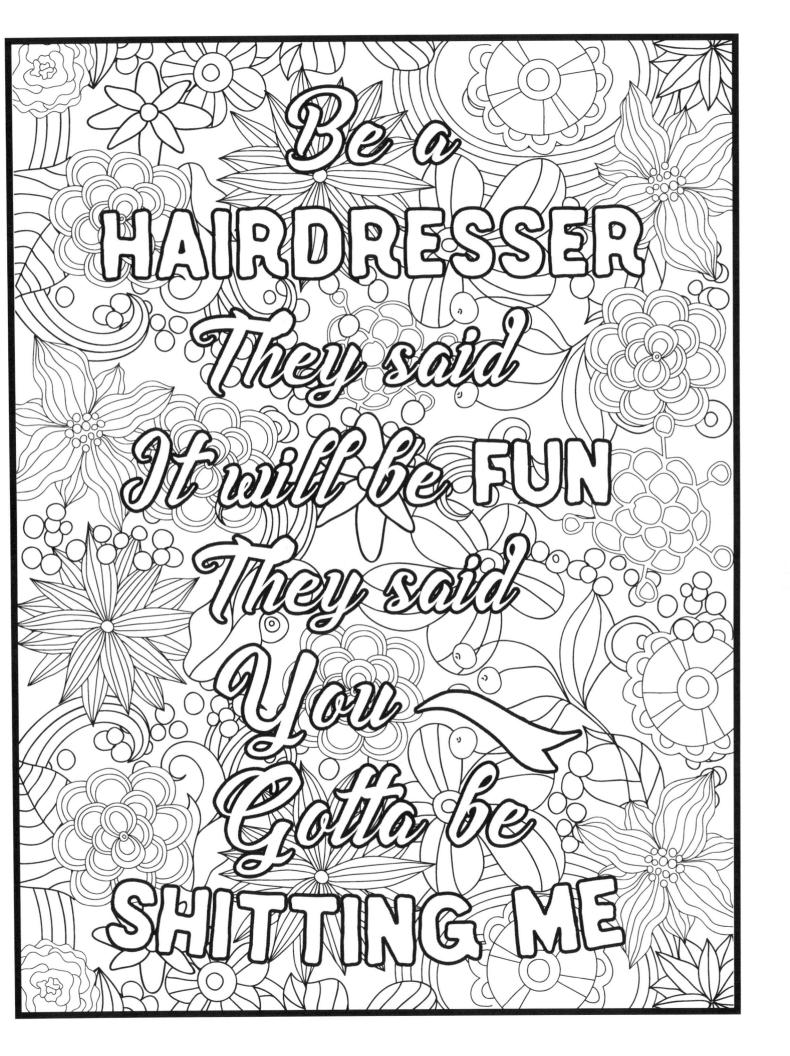

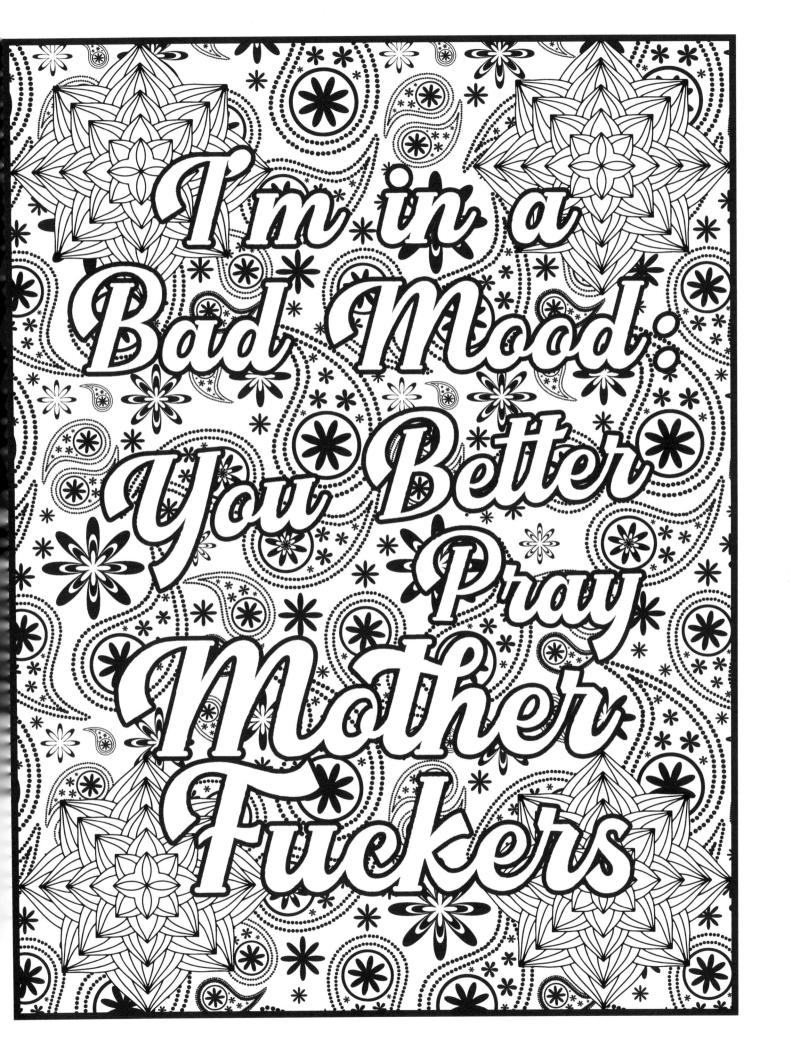

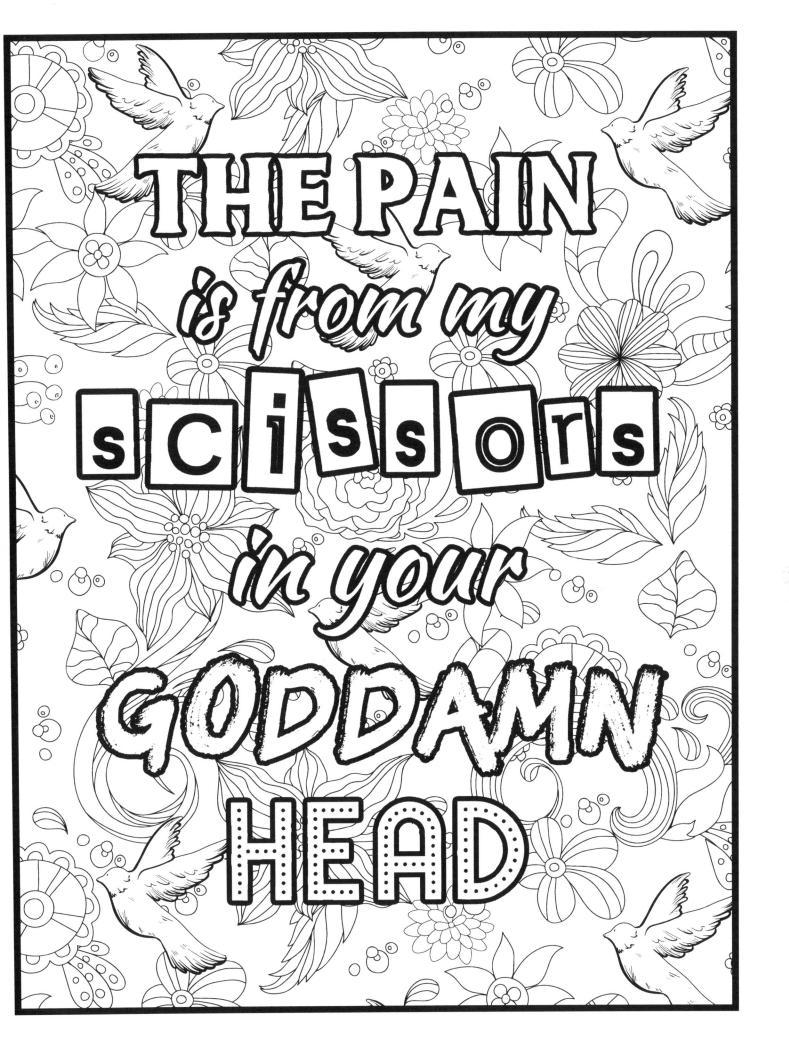

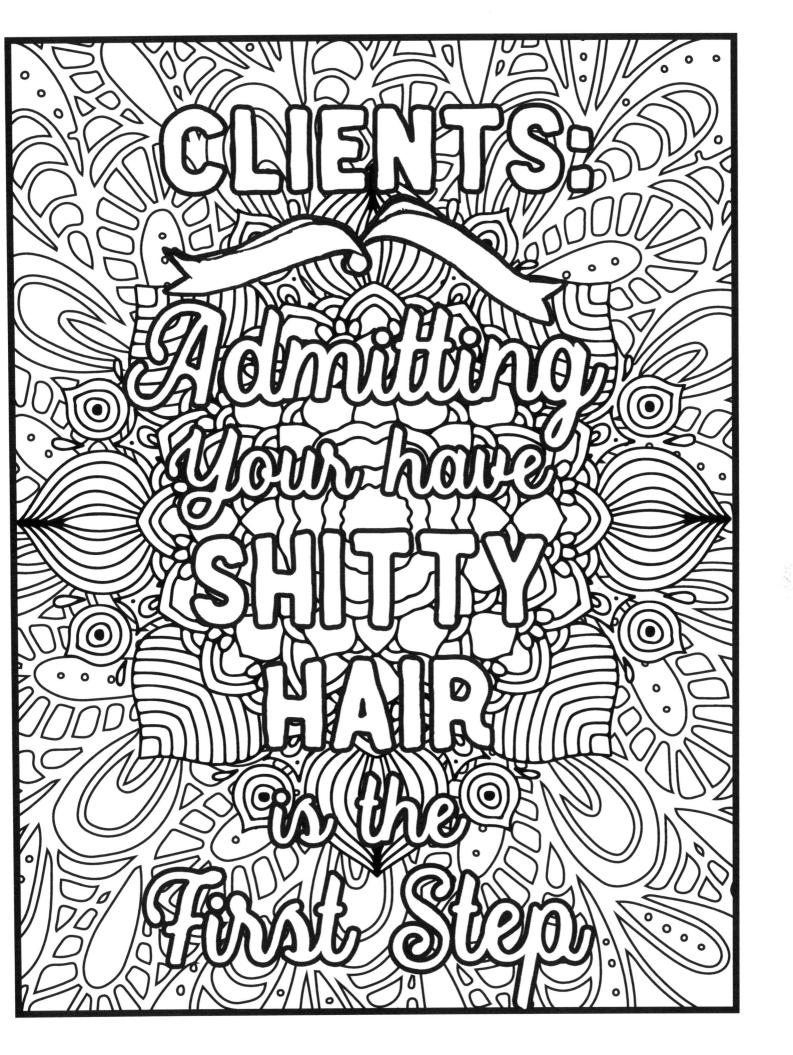

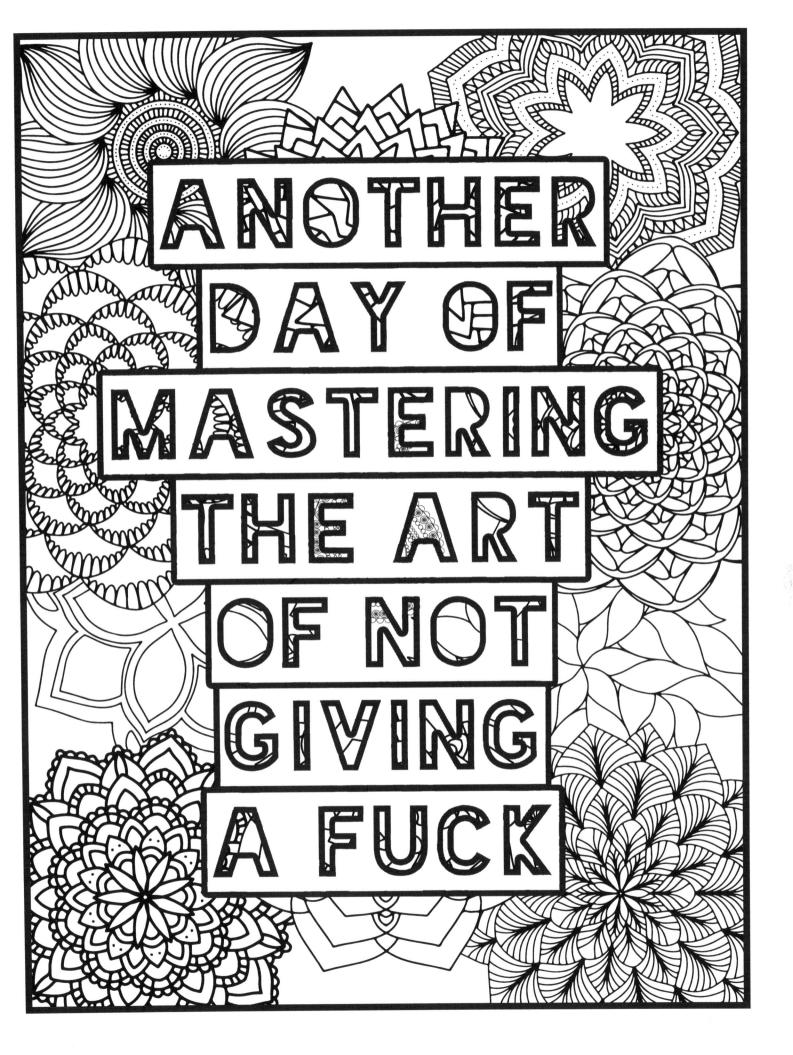

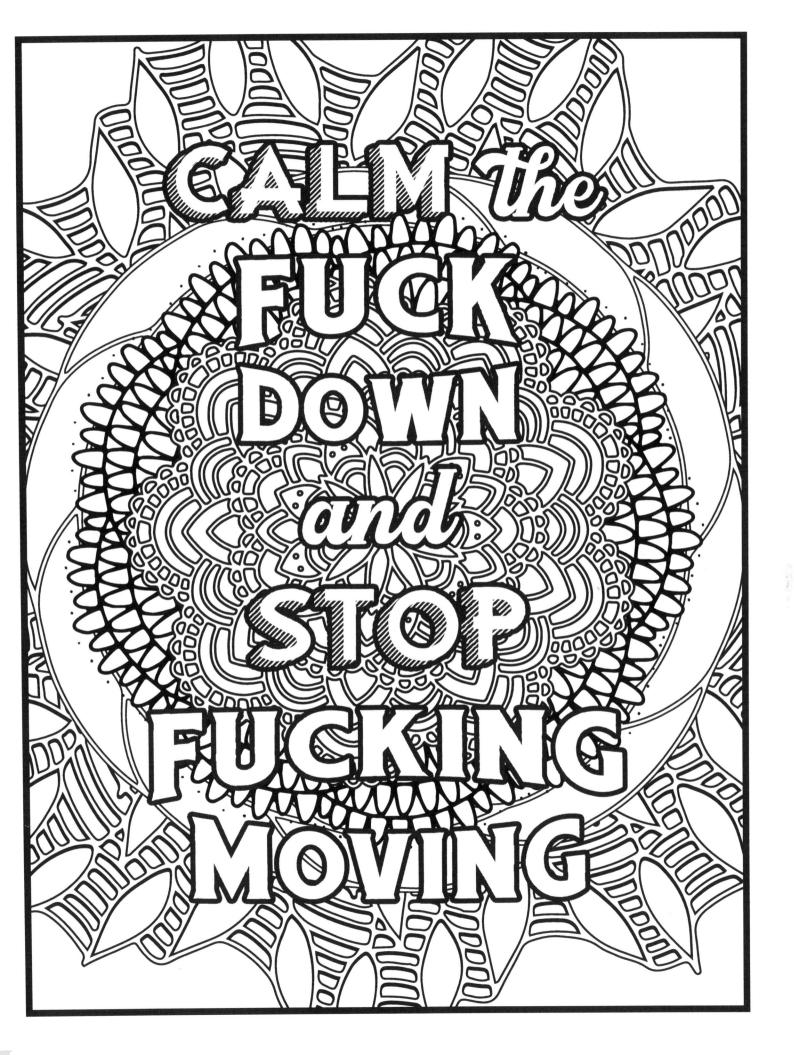

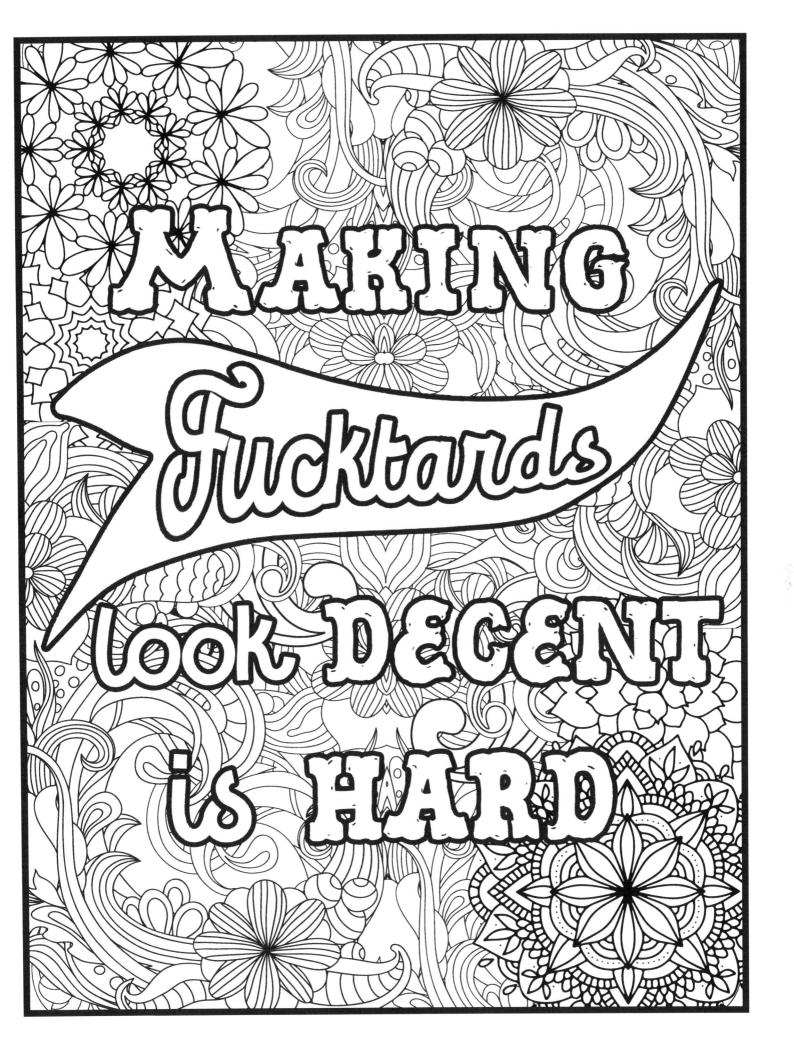

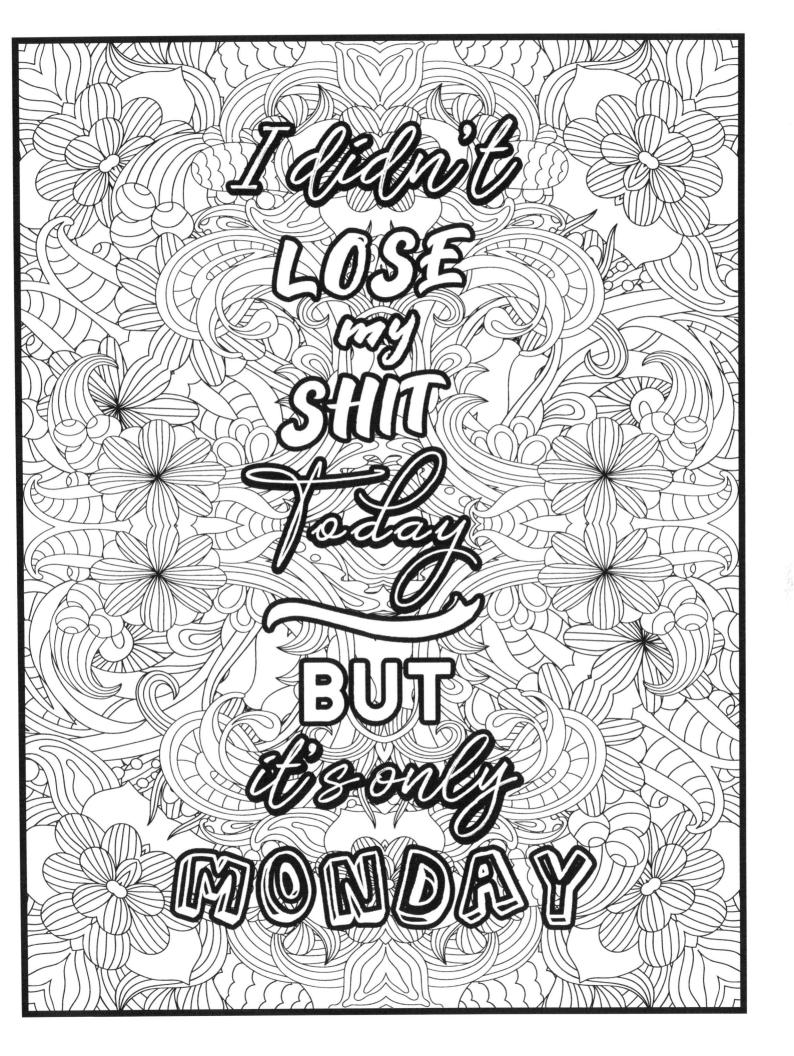

Colorbul Swearing Dreams

Colorful Swearing Oreans

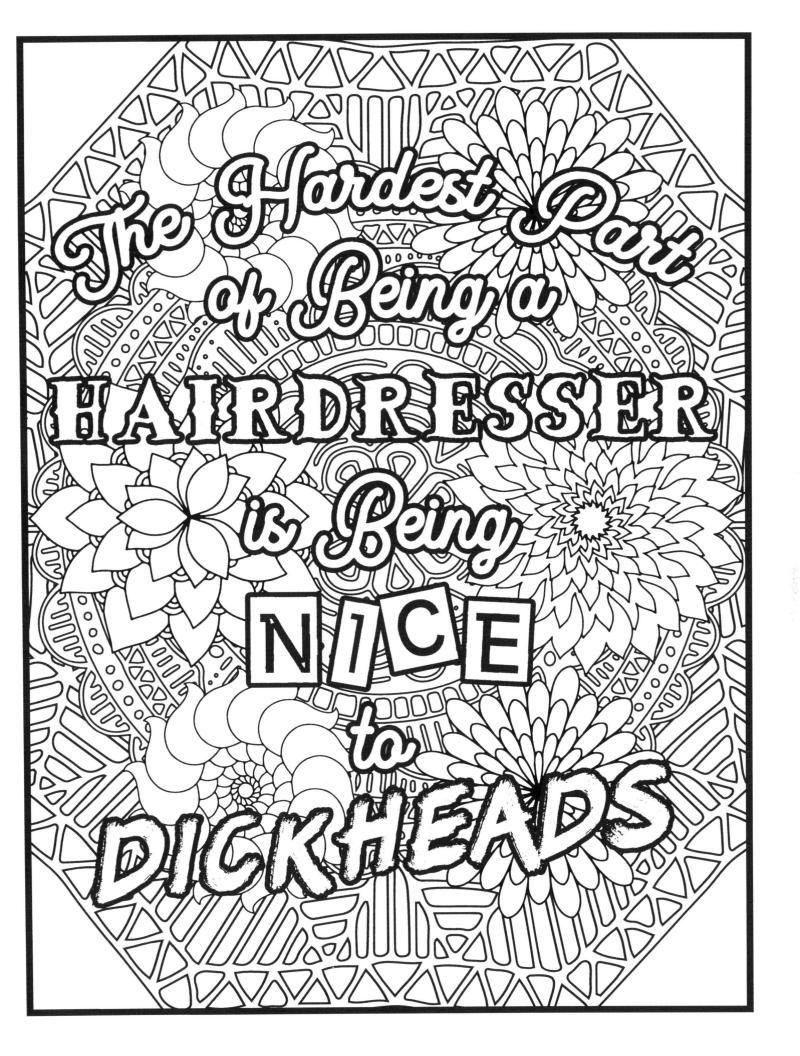

Colorful Swearing Dreams

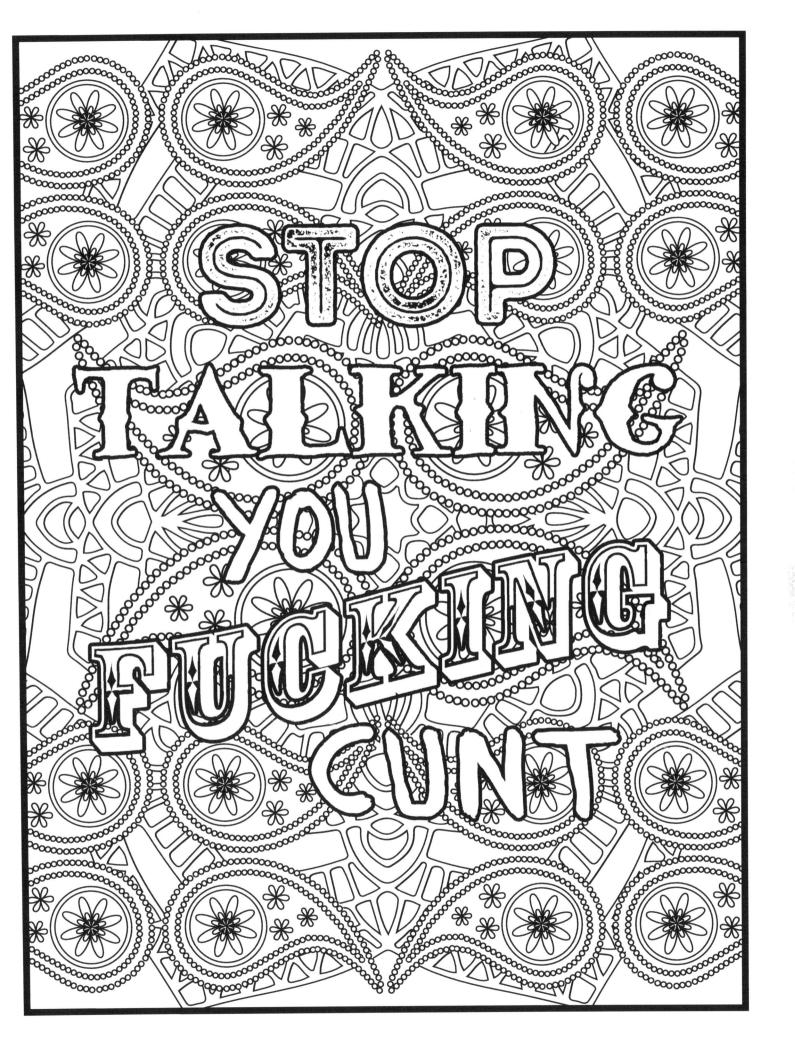

Colorbul Swearing Dreams

Colorful Swearing Dreams

How is your stress level now?

Would you be kind enough to review our book?

Did the book allow you to put all the stress out of your mind, body and soul? Hopefully you now feel fulfilled, relaxed and happy.

We sure put a lot of effort to provide you the best product possible that fits all your needs.

YOUR REVIEW is extremely valuable to us.

We don't see it as just a star rating, we read and study the feedbacks so we can consistently improve our products to shape them how you want them to be.

We take pride in making quality products for your satisfaction.

That is why, we would really appreciate if you can take few minutes of your time and leave us a review on our product's page.

That way, not only you will help other customers to make the right decision but you will also allow us to make other quality products that can make funny & unique gifts for your friends and family to just make them happy!

All Rights Reserved. Colorful Swearing Dreams

No part of this book may be reproduced, stored in a retrieval system, or transmitted in any form or by any means, electronic, mechanical, photocopying, recording, or otherwise, without the prior written permission of the author.

Colorful Swearing Dreams

Made in the USA Middletown, DE 06 April 2021

37128036R00027